**Portia George in books
@Amazon.com**

**Website Teacher
be-the-dream.org/**

Portia George
PG Enterprises Ministry
www.be-the-dream.org/

I SEE YOU

S.T.E.A.M.

CAREER CHOICES

ARTS

This book belongs to

Introduction

Welcome to "I See You: S.T.E.A.M. Career Options for Kids," an Arts book specifically designed to introduce young readers to the captivating world of Science, Technology, Engineering, Arts, and Mathematics (S.T.E.A.M.) careers.

Our book aims to inspire and educate children about the vast array of opportunities available in the S.T.E.A.M. field. Through engaging and informative content, we hope to ignite a passion for learning and exploration in our young readers.

With the help of our book, children will discover the exciting possibilities that await them in S.T.E.A.M. careers. From designing cutting-edge technology to creating beautiful works of art, the opportunities are endless.

Join us on this journey of discovery and let us help your child unlock their full potential in the world of S.T.E.A.M.

Art Conservationist:

A professional who restores and preserves works of art and artifacts to prevent damage and decay.

Fun Facts

Art Conservationist

1. Art conservationists are like superheroes for artwork. They work to save and protect paintings, sculptures, and other valuable artworks from getting damaged or worn out.

2. They use special tools and techniques to clean and repair artwork. It's like giving a makeover to the artwork to make it look beautiful again.

3. Art conservationists have to be very patient and careful when working on art. They take their time to make sure they don't accidentally damage the artwork while fixing it.

4. Sometimes, art conservationists use special light to examine the artwork closely. It helps them see things that are invisible to the naked eye and find hidden secrets in the artwork.

5. They can even use x-rays and other scientific methods to learn more about the artwork. It's like being a detective and uncovering the mysteries behind the paintings or sculptures.

6. Art conservationists work in special laboratories or studios where they can safely clean and restore artwork. It's like having their own magical workshop!

7. They wear special gloves when touching the artwork to keep it clean and free from oils and dirt on their hands.

8. Art conservationists need to have good artistic skills too. Sometimes, they have to repaint parts of a painting or recreate missing pieces to make it whole again.

9. They have to study and understand different types of materials like paint, wood, or stone to know how to care for them properly.

10. Art conservationists help make sure that future generations can enjoy and learn from the same artwork we love today. They play a crucial role in preserving our cultural heritage.

S.T.E.A.M

B

Bio Artist:

A bio artist combines art and biology to create works that explore scientific concepts, living organisms, and the ethical implications of biotechnology.

Fun Facts

Bio
Artist

1. Bio artists are like scientists who use living organisms, like plants, animals, and bacteria, to create amazing and unique artworks.

2. They combine art and science to explore and express ideas about nature, biology, and the environment.

3. Bio artists often work in laboratories or special studios where they can safely experiment and create their artworks.

4. They might use living plants to create living sculptures or use bacteria to make colorful patterns and designs.

5. Bio artists can even create artworks that change and grow over time. It's like having a living artwork that evolves and transforms!

6. They often collaborate with scientists and researchers to learn more about the living organisms they use in their art.

7. Bio artists sometimes create artworks that interact with the audience. For example, you might be able to touch or smell their creations!

8. They care a lot about the environment and often create artworks that raise awareness about ecological issues or inspire people to protect nature.

9. Bio artists are always curious and love to learn new things. They explore the connections between art, science, and the natural world.

10. Bio art can be surprising and even a little bit magical! It shows us that art can be found in unexpected places, like in the cells of living organisms.

Concept Artist:

Is responsible for generating visual ideas and designs for characters, environments, or objects in the early stages of media production, such as video games, films, or animations.

Fun Facts

Concept Artist

1. Concept artists are like dreamers and storytellers. They use their imagination to create ideas and designs for movies, video games, and animations.

2. They work closely with directors, game developers, and animators to bring their ideas to life. It's like being part of a big creative team!

3. Concept artists use pencils, paints, and digital tools to create sketches and drawings of characters, creatures, and amazing worlds.

4. They can make a simple doodle on a piece of paper turn into a fantastic and detailed artwork that inspires everyone who sees it.

5. Concept artists are like inventors. They create new and unique designs for things like spaceships, magical weapons, or even fantastical creatures.

6. They play with colors, shapes, and textures to make their artwork look exciting and visually appealing.

7. Concept artists often get to travel to different places and gather inspiration from real-life locations to create realistic and immersive worlds.

8. They have a big imagination and love to think outside the box. They can come up with wild and extraordinary ideas that make us say, "Wow!"

9. Concept artists sometimes make models or sculptures of their designs to help others visualize what they have in mind.

10. Their artwork helps set the mood and atmosphere for movies, video games, and animations. It's like painting the picture that guides the entire creative process.

Digital Illustrator:

Creates artistic and visual designs using digital tools, such as graphic tablets and illustrations software. They produce illustrations for various purposes.

Fun Facts

Digital Illustrator

1. Digital artists use computers, tablets, and special software to create amazing and colorful artworks.

2. They can create art with just a few clicks and strokes using digital brushes and tools. It's like painting with a magic pen!

3. Digital artists can experiment with different styles and techniques easily by changing settings on their digital devices.

4. They can undo and redo their artwork if they make a mistake, which allows them to explore their creativity without worrying about making errors.

5. Digital artists can draw and paint on a virtual canvas without needing any physical art supplies. It's like having an art studio inside a computer!

6. They can create animations and make their characters and drawings come to life by adding movement and sound.

7. Digital artists often use layers in their artwork, which allows them to draw and paint different parts separately and then combine them together.

8. They can use special effects and filters to add unique and magical touches to their artwork, like making it look like it's underwater or in outer space.

9. Digital artists can easily share their artwork with others online. They can post it on websites or social media platforms for people from all around the world to see and enjoy.

10. They can also collaborate with other artists digitally. They can work together on the same artwork even if they are in different parts of the world, like creating a masterpiece together!

S.T.E.A.M

E

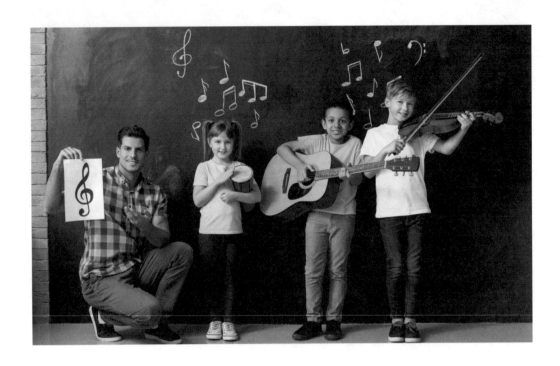

Ethnomusicologist:

Studies music of different cultures and societies, examining its cultural, social and historical context. They explore performances to gain insights on cultural diversity.

Fun Facts **Ethnomusicologist**

1. Ethnomusicologists are like music detectives. They study and learn about music from different cultures and places around the world.

2. They listen to and explore music from different countries, tribes, and communities to understand how it reflects their culture, traditions, and history.

3. Ethnomusicologists often travel to faraway places to meet musicians and experience music firsthand. It's like going on a musical adventure!

4. They play musical instruments from different cultures and learn how to sing songs in different languages. It's like having a passport to the world of music!

5. Ethnomusicologists study not just traditional music but also modern music styles and genres. They are interested in how music evolves and changes over time.

6. They collect and preserve recordings of music, just like collecting treasures. These recordings help us learn about music from the past and keep it alive for future generations.

7. Ethnomusicologists often dance and move to the music they study. It helps them understand how music is connected to movement and expression.

8. They study musical instruments and how they are made. Some instruments are very unique and have fascinating stories behind them.

9. Ethnomusicologists learn about the stories and myths that are often told through music. It's like discovering the secrets and tales hidden in melodies and rhythms.

10. They share their knowledge and passion for music with others, like teaching in schools or writing books. They want everyone to appreciate and celebrate the rich diversity of music in the world.

S.T.E.A.M

F

Fine Art Photographer:

Captures images that are considered artistic expressions rather than commercial or documentary purposes.

Fun Facts

Fine Art
Photographer

1. Fine art photographers are like painters, but instead of brushes and paints, they use cameras to create beautiful and artistic photographs.

2. They have a special eye for capturing unique and interesting moments in everyday life. They can turn ordinary things into extraordinary works of art.

3. Fine art photographers experiment with different lighting, angles, and compositions to make their photographs look visually stunning and captivating.

4. They can create photographs that tell stories or evoke different emotions, like happiness, wonder, or even sadness.

5. Fine art photographers can use digital cameras or film cameras, just like the ones used in the past. Some even develop their photos in a darkroom, just like old-time photographers.

6. They can print their photographs on special papers and create large, frame-worthy artworks that can be hung on walls and admired like paintings.

7. Fine art photographers often find inspiration in nature, architecture, or even in everyday objects like toys or flowers. They see beauty in the simplest things!

8. They can use editing software to enhance their photographs, like adjusting colors or adding special effects. It's like using digital brushes to paint on their photos.

9. Fine art photographers sometimes work on long-term projects, like capturing the changing seasons or documenting a specific community or culture. It's like creating a visual diary.

10.They love to share their photographs with others, whether it's through exhibitions, galleries, or even online. They want their art to be enjoyed and appreciated by many people.

S.T.E.A.M

G

Gallery Owner:

Owner manages and operates an art gallery, curating and exhibiting artworks by various artists. They oversee the gallery's operations, engage with artists and collector's and promote art appreciation and sales.

Fun Facts **Gallery Owner**

1. Gallery owners are like the hosts of a big art party! They run special places called galleries where people can come to see and appreciate artworks.

2. They curate and organize exhibitions by selecting and displaying different artworks by talented artists. It's like creating a big art show for everyone to enjoy.

3. Gallery owners often have a keen eye for spotting amazing artworks and artists. They can recognize talent and bring it to the attention of the public.

4. They work closely with artists to help them showcase their art and gain recognition. It's like being a supportive friend to the artists.

5. Gallery owners often have a deep knowledge of art history and different art styles. They can talk about the stories behind the artworks and help people understand them better.

6. They create a welcoming and inviting atmosphere in their galleries, making sure everyone feels comfortable and excited to explore the art.

7. Gallery owners sometimes organize special events and openings where people can meet the artists, ask questions, and learn more about their art.

8. They promote the artists and their artworks through marketing and advertising. They want to make sure that many people get to see and appreciate the art.

9. Gallery owners often build relationships with collectors and art enthusiasts. They help connect artists with people who want to buy or support their art.

10. They are passionate about art and love to share their knowledge and enthusiasm with others. They want everyone to experience the joy and inspiration that art can bring.

Hair Stylist:

Specializes in cutting, styling, and coloring hair. They work in salons or as freelancers, offering haircare services and helping clients achieve desired hairstyles.

Fun Facts Hair Stylist

1. Hair stylists are like magical wizards for hair! They have special skills to make our hair look stylish and beautiful.

2. They use different tools like scissors, combs, and hairdryers to create amazing hairstyles and transform our hair.

3. Hair stylists can cut hair in many different ways to create unique and personalized looks. They can give us a fresh new haircut that makes us feel confident and happy.

4. They can also style our hair for special occasions like weddings or parties. They can make our hair look fancy with braids, curls, or even cool updos.

5. Hair stylists often have their own special tricks to make our hair look healthy and shiny. They can recommend products and teach us how to take care of our hair.

6. They can also add colors and highlights to our hair. They use special dyes to create fun and vibrant looks, like adding streaks of pink, blue, or even rainbow colors!

7. Hair stylists love to be creative and try out new trends. They keep up with the latest hairstyles and fashion to give us trendy looks.

8. They can work in salons or even go on movie sets or fashion shows to style the hair of actors and models. It's like being part of the glamour and excitement of the entertainment industry.

9. Hair stylists often have great conversations with their clients while working on their hair. It's like having a fun chat with a friend.

10.They love seeing their clients leave the salon with a big smile on their face. It's a rewarding feeling to know they've made someone feel good about themselves.

S.T.E.A.M

1

Instrument Maker:

Crafts musical instruments by hand or using specialized tools and machinery. The work with wood, metal, or materials to create high-quality instruments.

Fun Facts

Instrument Maker

1. Instrument makers are like magicians who create musical instruments with their hands and tools.

2. They work with different materials like wood, metal, and strings to build instruments like guitars, violins, drums, and even pianos.

3. Instrument makers use special skills and knowledge to shape and assemble the pieces of an instrument, making sure it looks and sounds just right.

4. They can customize instruments based on a musician's preferences, like adding special designs or adjusting the size and shape to fit them perfectly.

5. Instrument makers often use traditional techniques that have been passed down through generations, keeping the art of instrument making alive.

6. They pay attention to every detail, from the tiniest screws to the smoothness of the surface. It's like crafting a work of art.

7. Instrument makers test and tune the instruments to ensure they produce the right sounds. They listen carefully to each note and adjust as needed.

8. They can repair and restore old instruments, bringing them back to life and making them playable again.

9. Instrument makers often have a deep appreciation for music. They understand how different components of an instrument work together to create beautiful melodies.

10.They work closely with musicians, learning from their feedback and collaborating to create instruments that inspire great music.

S.T.E.A.M

J

Jigsaw Puzzle Designer:

Creates puzzles by designing intricate and challenging patterns or images to be assembled. They consider puzzle difficulty, visual appeal, and manufacturing constraints.

Fun Facts

Jigsaw Puzzle Designer

1. Jigsaw puzzle designers are like puzzle wizards. They create the fun and challenging puzzles that we love to solve and put together.

2. They start by coming up with amazing pictures or illustrations that will be turned into puzzles. It's like painting a picture that can be taken apart and put back together.

3. Jigsaw puzzle designers carefully choose the number of puzzle pieces and the shape of each piece to make it just the right level of difficulty.

4. They use special computer software to design the puzzles and make sure all the pieces fit together perfectly.

5. Jigsaw puzzle designers sometimes hide secret details or surprises in their puzzles. It's like finding hidden treasures while solving the puzzle.

6. They can create different types of puzzles, like ones with big pieces for younger kids or ones with many pieces for older kids and adults.

7. Jigsaw puzzle designers love to create puzzles with different themes, like animals, nature, outer space, or even famous paintings. There's a puzzle for every interest!

8. They often work with illustrators or artists to turn their ideas into beautiful and colorful puzzle designs.

9. Jigsaw puzzle designers test the puzzles themselves to make sure they are fun and solvable. They want to make sure everyone can enjoy the challenge!

10. They feel happy and proud when they see people enjoying their puzzles and feeling a sense of accomplishment when they complete them.

S.T.E.A.M

K

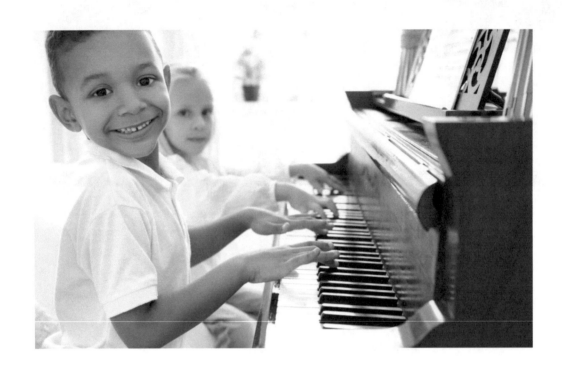

Keyboardist:

Specializes in playing keyboard instruments such as pianos, synthesizers or organs. They perform solo or as part of a group.

Fun Facts Keyboardist

1. Keyboardists are like musical wizards who can play many different sounds and create beautiful melodies using a keyboard instrument.

2. They play instruments like pianos, electronic keyboards, and synthesizers, which have a row of keys that produce different notes when played.

3. Keyboardists can play with both hands at the same time, using their left hand for lower notes and their right hand for higher notes. It's like playing two melodies together!

4. They can create different types of sounds, from soft and gentle notes to loud and powerful chords, by pressing different keys on the keyboard.

5. Keyboardists often have many buttons and knobs on their instrument, which they can use to change the sound or add special effects like reverb or echo.

6. They can play different music styles, like classical, jazz, pop, or even rock. Keyboardists are versatile and can adapt to various genres.

7. Keyboardists can also play other instruments using the keyboard, like creating a trumpet sound or a drumbeat. It's like having a whole orchestra at their fingertips!

8. They can create their own compositions and write songs using the keyboard. It's like being a composer and performer at the same time.

9. Keyboardists often perform in bands or music groups, where they play alongside other musicians like guitarists, drummers, and singers. It's like being part of a musical team!

10.They can make their keyboard "talk" by using a special technique called "pitch bending." It allows them to change the pitch of the notes and create expressive sounds.

S.T.E.A.M

L

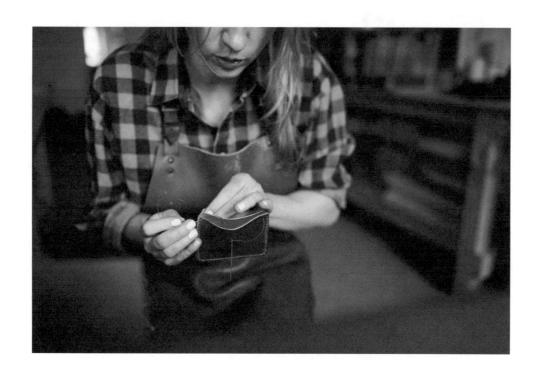

Leatherworker:

Crafts various items using leather, such as bags, belts, wallets or footwear. They cut, shape, and stitch leather, applying artistic designs and techniques to create functional and decorative products.

Fun Facts **Leatherworker**

1. Leatherworkers are like artisans who work with leather, which comes from the skin of animals like cows, sheep, or goats.

2. They use special tools like needles, thread, and punches to sew, shape, and decorate leather to make useful and beautiful items.

3. Leatherworkers can make things like wallets, belts, bags, shoes, and even costumes. It's like creating wearable art!

4. They often work with different types and colors of leather, from soft and smooth to thick and sturdy. Each type of leather has its own unique qualities.

5. Leatherworkers can add special designs and patterns to their creations by stamping, carving, or embossing the leather. It's like creating a work of art on the surface.

6. They use special techniques to dye and color the leather, turning it into vibrant shades like red, blue, or green.

7. Leatherworkers can repair and restore old leather items, giving them a new life and making them look as good as new.

8. They often work with their hands and need to have good hand-eye coordination and patience to create precise and detailed work.

9. Leatherworkers can personalize their creations by adding names or initials to make them unique and special for the person who will use them.

10. They love the smell and feel of leather and take pride in their craft. It's a skill that has been passed down through generations.

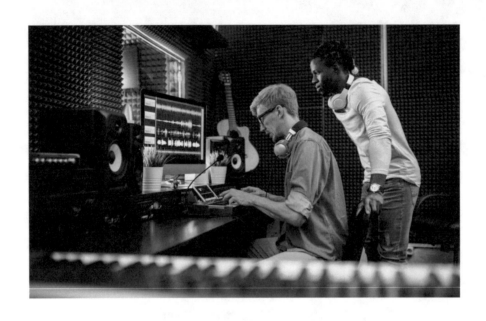

Music Producer:

Oversees the recording, production, and arrangement of musical compositions. They work closely with musicians, sound engineers, and other professionals to shape the overall sound.

Fun Facts

Music Producer

1. Music producers are like the directors of a song or an album. They work behind the scenes to make sure everything sounds just right.

2. They help musicians and artists create their music by giving guidance, making decisions about the sound, and adding special effects.

3. Music producers use special equipment and software to record and mix the different sounds and instruments in a song. It's like being a sound engineer!

4. They can make a song sound more exciting by adding extra beats, catchy melodies, or even fun sound effects like clapping or whistling.

5. Music producers often work in recording studios, which are special places where musicians can record their songs and add all the different layers of sound.

6. They work closely with artists, singers, and musicians to bring their ideas to life. It's like being a team leader and collaborator.

7. Music producers can make a song sound different by changing the tempo (how fast or slow it is) or the style of music it's played in.

8. They have a good ear for music and can identify what sounds good together. They help create a balance between all the different elements of a song.

9. Music producers sometimes remix songs, which means they take an existing song and make it sound new and different by adding their own touch to it.

10. They play a crucial role in the success of a song or an album. They make sure the music is well-produced and enjoyable for people to listen to.

New Media Artist:

Creates art using digital technologies, such as interactive installations, virtual reality, or digital projections.

Fun Facts

New Media Artist

1. New media artists use technology and digital tools to create art. They combine traditional art forms with computers, video, animation, and interactive elements.

2. They can create artworks that move, change colors, or even respond to touch or sound. It's like art that comes to life!

3. New media artists often work with computers and specialized software to design and manipulate images, videos, and sound.

4. They can create virtual worlds and immersive experiences using virtual reality or augmented reality. It's like stepping into a different dimension!

5. New media artists can experiment with different forms of art, like creating digital paintings, animations, interactive installations, or even video games.

6. They can use coding and programming to make their artworks interactive. It's like giving the audience the power to influence and shape the art.

7. New media artists often work collaboratively with other artists, designers, and even engineers to bring their ideas to life. It's like a team effort!

8. They can use social media and online platforms to showcase and share their art with people all over the world. It's like having a virtual gallery!

9. New media artists often explore new and emerging technologies to create art that reflects our ever-changing digital world.

10. They have a playful and experimental approach to art. They love pushing boundaries and finding new ways to express their ideas through technology.

S.T.E.A.M

O

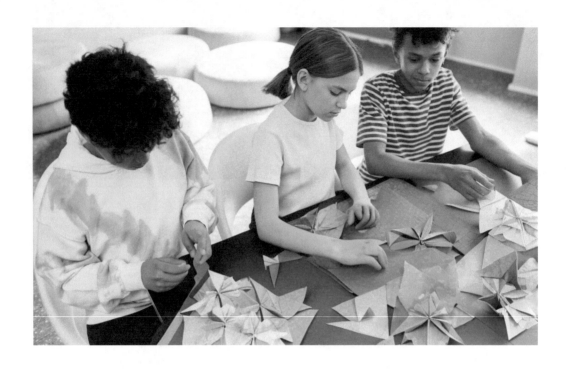

Origami Artists:

Creates intricate and artistic designs by folding paper without cutting or gluing. They transform flat paper into three-dimensional sculptures, through precise folding techniques.

Fun Facts

Origami Artist

1. Origami artists are like magicians who can transform a simple sheet of paper into amazing sculptures using folding techniques.

2. The word "origami" comes from Japan, where "ori" means folding and "kami" means paper.

3. Origami artists can create all sorts of things, like animals, flowers, airplanes, and even entire landscapes, using just one piece of paper.

4. They follow special instructions called "origami diagrams" to fold the paper in specific ways to create different shapes and designs.

5. Origami artists can use different types of paper, like colorful or patterned paper, to make their creations even more interesting and beautiful.

6. They can design their own origami models, coming up with new and unique creations that no one has seen before.

7. Origami artists sometimes compete in origami competitions to show off their skills and creativity. It's like a paper-folding championship!

8. They can make origami creations that move, like flapping wings or jumping frogs. It's like bringing paper to life!

9. Origami artists often use their creations to decorate spaces or make handmade gifts for friends and family. It's like sharing their love for paper art.

10. They enjoy teaching others how to fold origami and sharing the joy of creating something beautiful with just a piece of paper.

S.T.E.A.M

P

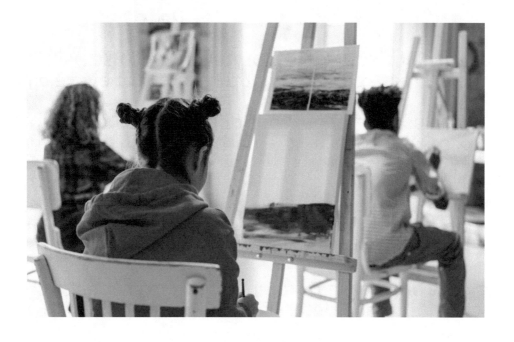

Painter:

Creates artworks using various painting techniques, such as oil, acrylic, watercolor, or mixed media, to express their artistic vision and convey emotions or concepts.

Fun Facts **Painter**

1. Artwork painters are like storytellers who use paint and brushes to create pictures that tell a story or evoke emotions.

2. They can use different types of paint, like watercolors, acrylics, or oils, to create their artwork. Each type of paint has its own unique qualities.

3. Artwork painters can paint on different surfaces, like canvas, paper, or even walls. It's like turning a blank surface into a colorful masterpiece!

4. They use brushes of different sizes and shapes to create different effects and details in their paintings. It's like having a magical paint wand!

5. Artwork painters can choose from a wide range of subjects to paint, like landscapes, animals, people, or even abstract shapes. There's no limit to their creativity!

6. They mix different colors to create new ones. It's like being a scientist in an art laboratory!

7. Artwork painters can use their imagination to create imaginary worlds or paint scenes from real life. It's like stepping into their own painted universe.

8. They can experiment with different painting techniques, like splattering paint, blending colors, or using texture to add depth to their artwork.

9. Artwork painters often have their own unique style and way of painting that makes their artwork recognizable. It's like having their own artistic signature.

10.They can display their artwork in galleries or exhibitions for people to see and appreciate. It's like sharing a piece of their creativity with the world.

S.T.E.A.M

Q

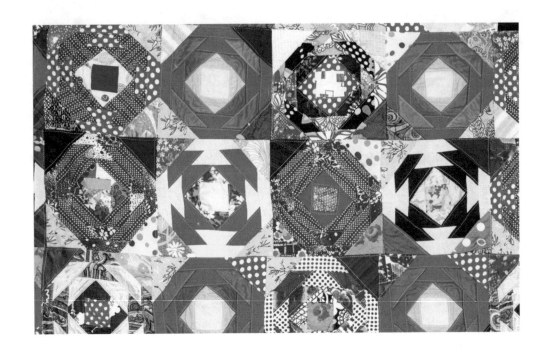

Quilt Designer:

Creates original designs for quilts, which are layered fabric constructions used for warmth, decoration, or artistic expression.

Fun Facts

Quilt Designer

1. Quilt designers are like artists who create beautiful and cozy blankets made of fabric.

2. They use different fabrics, colors, and patterns to design and piece together unique quilt designs.

3. Quilt designers can create quilts in all sorts of shapes and sizes, like squares, rectangles, or even more complex shapes like stars or animals.

4. They can combine different fabric pieces to create interesting patterns, like stripes, polka dots, or even pictures of animals or objects.

5. Quilt designers often use a special sewing technique called quilting to stitch together the layers of fabric in the quilt, making it warm and cozy.

6. They can make quilts with different themes, like nature, animals, or even characters from books or movies. There's a quilt design for every interest!

7. Quilt designers sometimes add extra details to their quilts, like embroidery, appliqué (sewing fabric pieces on top of the quilt), or even buttons and beads for decoration.

8. They can create personalized quilts by adding names or initials, making them extra special for the person who will use them.

9. Quilt designers often work with other quilters or sewers to share ideas and inspiration. It's like being part of a creative quilting community!

10. They feel a sense of joy and satisfaction when they see people snuggling up with their quilts and feeling cozy and warm.

S.T.E.A.M

R

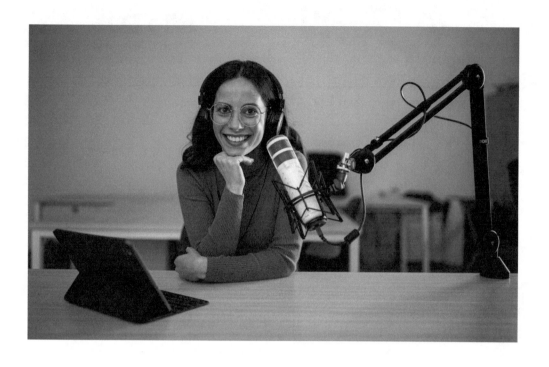

Radio DJ:

Hosts radio programs, selects and plays music, and engages with listeners through live broadcasts.

Fun Facts **Radio DJ**

1. Radio DJs are like magical voices on the radio who play music, share stories, and make people smile.

2. They work in radio stations and use special equipment to broadcast their voices and the music they play.

3. Radio DJs can choose different types of music to play, like pop, rock, hip-hop, or even children's songs. They make sure to play songs that people will enjoy.

4. They can also talk on the radio, sharing interesting facts, telling jokes, or even interviewing special guests. It's like having a conversation with the listeners!

5. Radio DJs have a special skill called "voice acting" that helps them sound enthusiastic and friendly on the radio. They have the power to make people feel happy and entertained.

6. They can take requests from listeners, who can call in or send messages to ask for their favorite songs to be played on the radio.

7. Radio DJs often have their own special radio names or nicknames that make them unique and memorable.

8. They need to have good knowledge of music and stay up-to-date with the latest songs and trends. It's like being a music expert!

9. Radio DJs sometimes host special radio shows or events, like birthday parties or concerts, where they entertain a large audience through the radio waves.

10.They feel a special connection with their listeners, even though they can't see them. Radio DJs know that they are making people smile and bringing joy to their day.

S.T.E.A.M

S

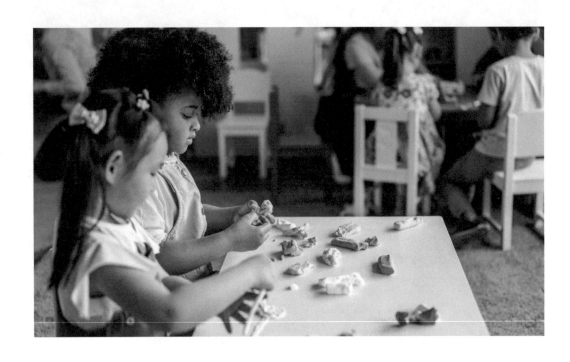

Sculptor:

Creates three-dimensional artworks by shaping or carving materials, such as clay, stone, metal, or wood. They use tools and techniques to transform materials into expressive sculptures.

Fun Facts

Sculptor

1. Sculptors are like artists who use their hands and special tools to create sculptures out of materials like clay, stone, metal, or even recycled materials.

2. They can create sculptures of people, animals, objects, or even abstract shapes. It's like bringing things to life in 3D form!

3. Sculptors can work with different materials, like clay that can be molded and shaped easily or hard materials like stone that require more strength and precision.

4. They use tools like chisels, hammers, and carving knives to shape and refine their sculptures. It's like being a sculpting wizard with magical tools!

5. Sculptors often work with their hands, feeling the texture of the material and using their sense of touch to shape the sculpture.

6. They can create sculptures of all sizes, from tiny figurines that fit in the palm of your hand to large statues that can be taller than a person.

7. Sculptors can create sculptures that are meant to be displayed outdoors, like in parks or gardens. These sculptures can withstand different weather conditions.

8. They can also create sculptures that are meant to be touched and interacted with, like tactile sculptures or pieces that make sound when touched.

9. Sculptors can create sculptures that tell stories or convey emotions. It's like freezing a moment in time and expressing it through art.

10. They enjoy seeing people's reactions and emotions when they interact with their sculptures. It's like bringing joy, wonder, or even curiosity to others through their artwork.

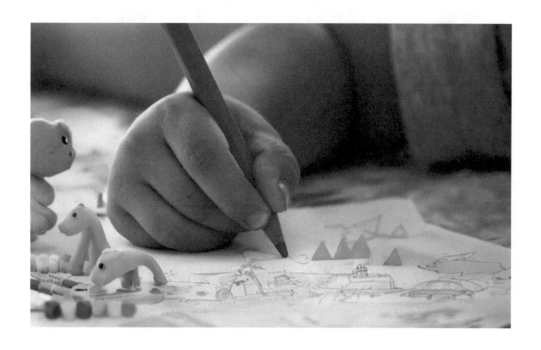

Toy Designer:

Creates concepts, sketches, and prototypes for toys and games. They consider the market appeal to develop innovative and engaging toys for children or collectors.

Fun Facts **Toy Designer**

1. Toy designers are like magical inventors who create toys that are fun to play with and spark imagination.

2. They come up with ideas for new toys and bring them to life using their creativity and design skills.

3. Toy designers often work with different materials, like plastic, fabric, or even wood, to create toys of all shapes and sizes.

4. They consider things like safety, durability, and age-appropriate features when designing toys to make sure they are fun and safe to play with.

5. Toy designers can create all kinds of toys, from dolls and action figures to cars, board games, and even puzzles. There's a toy for every interest!

6. They can create toys that have special functions, like toys that make sounds, light up, or even move on their own. It's like having toys with superpowers!

7. Toy designers sometimes work with other experts, like engineers or artists, to bring their toy designs to life. It's like a team effort!

8. They enjoy testing their toys to make sure they are fun and engaging for kids. It's like getting to play with toys all day!

9. Toy designers can create toys based on popular movies, TV shows, or even books. It's like bringing your favorite characters and stories to life through toys.

10.They love seeing the joy on kids' faces when they play with the toys they've designed. Toy designers know they're creating something special that brings happiness and fun to children all around the world.

S.T.E.A.M

U

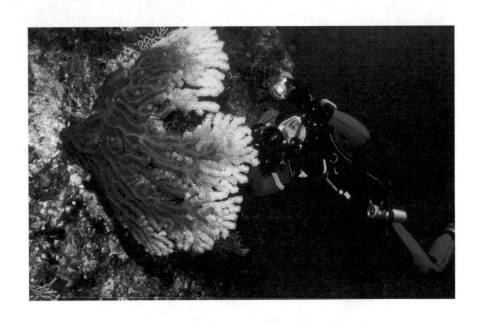

Underwater Photographer:

Captures images or videos in underwater environments. To document marine life, underwater landscapes, or activities for scientific, artistic, or commercial purposes.

Fun Facts

Underwater Photographer

1. Underwater photographers are like adventurers who explore the underwater world and capture amazing pictures of marine life.

2. They use special cameras and equipment that are designed to work underwater and capture clear and colorful images.

3. Underwater photographers can take pictures of beautiful coral reefs, colorful fish, playful dolphins, and even majestic sea turtles.

4. They often have to dive deep into the ocean to find the most interesting underwater scenes and creatures.

5. Underwater photographers need to be strong swimmers and have scuba diving skills to move freely underwater and get close to their subjects.

6. They may use special underwater lighting techniques to bring out the vibrant colors and details in their photographs.

7. Underwater photographers sometimes have to be patient and wait for the perfect moment to capture a particular fish or marine animal in action.

8. They can document underwater habitats and ecosystems, helping us learn more about the incredible diversity of life beneath the sea.

9. Underwater photographers often have a deep love and respect for the ocean and its creatures. They work to raise awareness about the importance of protecting our oceans.

10. They feel a sense of awe and wonder when they see the beauty and diversity of the underwater world through their camera lens.

S.T.E.A.M

V

Visual Effects Artist:

Creates visual effects, animations, or graphics for films, television shows, or advertisements. Integrating computer-generated imagery into live-action footage and enhance visual storytelling.

Fun Facts

Visual Effects Artist

1. Visual effects (VFX) artists are like magicians who use computer software and special techniques to create amazing and realistic effects in movies, TV shows, and video games.

2. They can make superheroes fly, create imaginary creatures, or even make it look like someone is walking on the moon!

3. VFX artists work with a team of professionals, like directors and animators, to bring their creative visions to life on the screen.

4. They use powerful computers and specialized software to manipulate and enhance images and create realistic visual effects.

5. VFX artists can add explosions, fire, or even create entire fantasy worlds using their digital skills. It's like having a magic wand for creating movie magic!

6. They can make actors disappear or change their appearance using digital tools. It's like being able to transform people into different characters!

7. VFX artists often have a strong background in art and technology. They combine their creativity with technical skills to create stunning visual effects.

8. They enjoy experimenting and finding new ways to push the boundaries of what is possible in visual effects. It's like being a digital inventor!

9. VFX artists often work on exciting and action-packed projects, like superhero movies or thrilling adventure films.

10. They feel a sense of pride and accomplishment when they see their visual effects on the big screen, knowing that they helped create a magical and immersive experience for the audience.

S.T.E.A.M

W

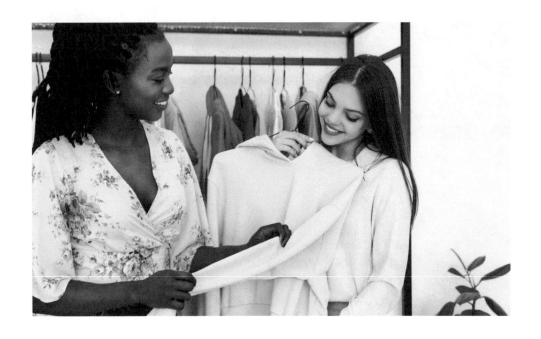

Wardrobe Stylist:

Selects and curates clothing and accessories for individual's, models, or performers. They create cohesive looks, consider fashion trends and aesthetics.

Fun Facts

Wardrobe Stylist

1. Wardrobe stylists are like fashion wizards who help choose and put together outfits for people in movies, TV shows, or even photo shoots.

2. They have a great sense of fashion and know how to combine different clothes and accessories to create stylish looks.

3. Wardrobe stylists often work closely with directors or photographers to understand the vision and story behind a project and choose outfits that match the characters or themes.

4. They can create outfits for all kinds of situations and settings, like casual everyday looks, fancy formal attire, or even costumes for special events.

5. Wardrobe stylists have a keen eye for colors, patterns, and textures. They know how to mix and match different pieces to create visually appealing outfits.

6. They often research and stay updated on the latest fashion trends to make sure the outfits they create are modern and fashionable.

7. Wardrobe stylists can work with accessories like hats, scarves, belts, or jewelry to add extra flair to an outfit and make it unique.

8. They may have to shop for clothes and accessories, visiting different stores or even working with fashion designers to find the perfect pieces for a project.

9. Wardrobe stylists often have to organize and take care of the clothes and accessories they work with, making sure everything is clean, ironed, and ready to go.

10.They feel a sense of accomplishment when they see the characters or models wearing their outfits and looking their best. Wardrobe stylists help bring a visual story to life through fashion!

Xylographer:

They carve images or designs onto a block of wood and use it to create prints by applying ink to the raised surface and transferring it onto paper.

Fun Facts **Xylographer**

1. Xylographers are like artists who create pictures or designs by carving them into blocks of wood.

2. They use special tools like knives and gouges to carefully carve away the wood, leaving behind the parts that will be printed.

3. Xylography is one of the oldest forms of printing and has been practiced for centuries around the world.

4. Xylographers often work with different types of wood, like cherry or boxwood, which have specific qualities that make them suitable for carving.

5. They can create beautiful and intricate designs by carving lines, shapes, and patterns into the woodblock.

6. Xylographers use ink or paint to apply color to the carved woodblock and then press it onto paper or fabric to create prints.

7. Xylography can be used to create prints of all sizes, from small illustrations to large posters or even fabric prints.

8. Xylographers sometimes collaborate with writers or storytellers to create illustrated books or print stories.

9. Xylography requires patience and precision, as the artist needs to carefully plan and carve each detail before printing.

10.Xylographers enjoy seeing their prints come to life as they press the carved woodblock onto paper and reveal the final image. It's like a magical moment of creation!

S.T.E.A.M

Y

Yarn Dyer:

A textile artist who dyes yarn using various dyeing techniques and color combinations. They create unique and vibrant yarns for knitting, crocheting and other fiber art projects.

Fun Facts Yarn Dyer

1. Yarn dyers are like artists who add vibrant colors to yarn to make it look beautiful and exciting.

2. They use special dyes, like paints for yarn, to add color to the plain yarn.

3. Yarn dyers can create all kinds of colors, from bright and bold to soft and pastel shades.

4. They mix different dyes to create unique colors that are not found naturally.

5. Yarn dyers often experiment with different dyeing techniques, like dip-dyeing, hand-painting, or even tie-dyeing, to create interesting patterns and effects on the yarn.

6. They can dye yarn in small batches or in large quantities, depending on the demand.

7. Yarn dyers take care to make sure the colors are evenly spread throughout the yarn, so it looks beautiful when knitted or crocheted into projects.

8. They might use natural dyes, like fruits, vegetables, or even flowers, to create eco-friendly and unique color variations.

9. Yarn dyers enjoy playing with color combinations and finding inspiration from nature, art, or even their own imagination.

10.They feel a sense of joy and satisfaction when they see people using their colorful yarn to create beautiful handmade items like scarves, hats, or even blankets.

S.T.E.A.M

Z

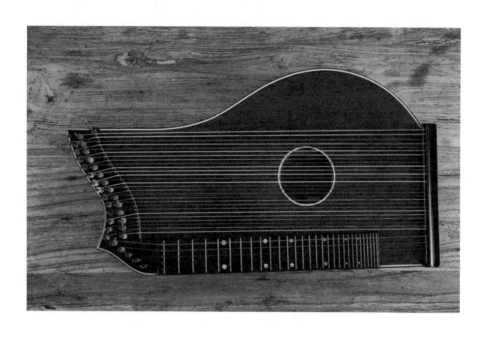

Zither Player:

A musician who plays this stringed instrument by plucking or strumming. They preform solo or as part of an ensemble, showcasing the unique sound and versatility of the zither.

Fun Facts

Zither Player

1. Zither players are like musicians who play a musical instrument called the zither, which has a beautiful and unique sound.

2. The zither is a stringed instrument that is played by plucking or strumming the strings with the fingers or with a special pick.

3. The zither is a very old instrument that has been played for hundreds of years in different parts of the world.

4. Zither players can create all kinds of music with their instrument, from soothing melodies to lively tunes that make you want to dance.

5. The zither has a special resonance and can produce a lovely, gentle sound that is perfect for relaxing or daydreaming.

6. Zither players often have to learn how to read sheet music, which is a special way of writing music down on paper, to play different songs.

7. They might play the zither solo, which means playing it all by themselves, or they might play with other musicians in a band or orchestra.

8. Zither players can perform in different places, like concerts, festivals, or even in parks, where people can gather to listen to their music.

9. Some zither players are very skilled and can play their instrument very fast, creating a flurry of beautiful notes that amaze the listeners.

10. Zither players love to share their music with others and enjoy seeing people smile and tap their feet to the rhythm of the zither.

1. Louis Braille, who invented the Braille system for the blind, was only **15** years old when he created it.

2. Taylor Wilson built a nuclear reactor in his parents' garage at the age of **14**.

3. Moziah Bridges started his own bow tie company, Mo's Bows, at the age of **9**.

4. Gitanjali Rao, at the age of **11**, developed a device to detect lead in drinking water.

5. Mikaila Ulmer, aged **11**, founded a lemonade company called Me & the Bees.

6. Shubham Banerjee, at **13**, created a low-cost Braille printer using a Lego Mindstorms kit.

7. Alia Sabur became the world's youngest college professor at the age of **19**.

8. Ayan Qureshi, a British child prodigy, became a certified Microsoft Systems Engineer at the age of **6**.

9. Alex Knoll, at the age of **12**, created the Ability App to help people with disabilities find accessible locations.

10. Adora Svitak, aged **7**, became the youngest published author in the United States.

11. Richard Turere, a Maasai boy from Kenya, invented a lion deterrent system at the age of **13**.

12. Mikaela Ulmer, aged **4**, appeared on the TV show "Shark Tank" and secured a deal for her bee-friendly lemonade business.

13. Emily Cummins invented a sustainable refrigerator that doesn't require electricity at the age of **16**.

Young S.T.E.A.M Achievers

14. Rachel Zimmerman Brachman, at **12**, won the top prize at the Google Science Fair for her research on cancer.

15. Robert Nay, aged **14**, created the popular mobile game "Bubble Ball."

16. Brittany Wenger developed an artificial intelligence program to detect breast cancer at the age of **17**.

17. Riri Williams, a Marvel Comics character, became Ironheart and took over as the superhero when she was just **15**.

18. Kiowa Kavovit, aged **6**, secured a deal on "Shark Tank" for her eco-friendly and non-toxic cleaning products.

Young S.T.E.A.M Achievers

19. George Nkencho, aged **9**, published a book on the solar system.

20. Max Loughan, a **13**-year-old inventor, developed a device that harnesses energy from radio waves.

21. Jack Andraka, aged **15**, created a low-cost, early detection test for pancreatic cancer.

22. Elif Bilgin, at **16**, won the Scientific American Science in Action Award for her project on bioplastics made from banana peels.

23. Anne-Marie Imafidon, aged **20**, became one of the youngest people to graduate with a master's degree in mathematics and computer science from the University of Oxford.

24. Andrew Duff, aged **9**, developed a device to help find and rescue people buried under debris during earthquakes.

25. Peyton Robertson, aged **12**, won the Discovery Education 3M Young Scientist Challenge for his innovative sandbag design to prevent flooding.

26. William Kamkwamba, a Malawian inventor, built a windmill from spare parts at the age of **14**, bringing electricity to his village.

27. Jack Andraka, aged **15**, developed a paper sensor that can detect pancreatic, ovarian, and lung cancer with high accuracy.

28. Ann Makosinski, aged **15**, invented a flashlight powered by body heat for which she won the Google Science Fair.

29. Moziah Bridges, aged **12**, secured a deal with NBA to create a line of bow ties for basketball fans.

30. Taylor Wilson, aged **17**, became the youngest person to achieve nuclear fusion in a homemade reactor.

31. Shubham Banerjee, aged **12**, founded Braigo Labs and created a low-cost Braille printer using off-the-shelf Lego parts.

32. Angela Zhang, aged **17**, won the Siemens Competition in Math, Science & Technology for her cancer-targeting nanoparticle research.

Young S.T.E.A.M
Achievers

33. Easton LaChappelle, aged **19**, developed a 3D-printed robotic arm that can be controlled by brainwaves.

34. Lydia Sebastian, aged **12**, achieved a perfect score on the Mensa IQ test, surpassing the scores of Albert Einstein and Stephen Hawking.

35. Tanishq Abraham, aged **13**, graduated from American River College with three associate degrees in math, science, and foreign language studies.

36. Arsh Shah Dilbagi, aged **16**, created a device called "TALK," which converts breath signals into speech to assist people with speech impairments.

Young S.T.E.A.M Achievers

37. Alia Sabur, aged **18**, became the youngest-ever university professor in the world, teaching engineering at Konkuk University in South Korea.

38. Tiera Guinn, aged **22**, works as a rocket structural analyst for NASA, helping design the Space Launch System.

39. Brittany Wenger, aged **17**, developed an artificial neural network to diagnose breast cancer with 99% accuracy.

40. Rylan Grayston, aged **24**, invented the Peachy Printer, an affordable 3D printer that raised over $600,000 on Kickstarter.

Young S.T.E.A.M Achievers

41. Kenyan students Olivia and Richard, both aged **15**, developed a mobile app called "I-cut" to help end female genital mutilation.

42. Elif Bilgin, aged **16**, won the Science in Action award at the Google Science Fair for her project on developing bioplastics from banana peels.

43. Maanasa Mendu, aged **15**, designed a device that harnesses wind, solar, and vibrational energy to generate electricity for developing countries.

44. Jordan Casey, aged **14**, developed several successful mobile games and became one of the youngest app developers in Europe.

Young S.T.E.A.M Achievers

45. Keiana Cavé, aged **22**, discovered a potential method for cleaning up oil spills using a combination of oil-absorbing polymers and magnets.

46. Jacob Barnett, aged **14**, became a college student and researcher in quantum physics at the age of 10.

47. Mallory Kievman, aged **13**, invented a lollipop that helps soothe sore throats, known as the "Zollipops."

48. Samantha Marquez, aged **20**, developed a water purification system using solar energy to provide clean drinking water in developing countries.

49. Gitanjali Rao, aged **15**, invented a device called "Tethys" that detects lead in water and won the Discovery Education 3M Young Scientist Challenge.

50. Alaina Gassler, aged **14**, created a system that eliminates blind spots in cars using a camera and projector to display images on the inside pillar.

51. Shree Bose, aged **17**, won the Google Science Fair for her research on a potential treatment for ovarian cancer.

52. Joey Hudy, aged 16, impressed President Barack Obama with his marshmallow cannon invention at the White House Science Fair.

53. Caroline Crouchley, aged **14**, created a biodegradable alternative to plastic from shrimp shells.

Young S.T.E.A.M Achievers

54. Moziah Bridges, aged **19**, expanded his bow tie business, Mo's Bows, and secured partnerships with major retailers.

55. Rachel Zimmerman Brachman, aged **15**, developed a new method to treat cancer by combining gold nanoparticles with radiation therapy.

56. Anika Chebrolu, aged **14**, won the 3M Young Scientist Challenge for her discovery of a potential treatment for COVID-19.

57. Kiara Nirghin, aged **16**, developed a biodegradable and superabsorbent polymer from orange peels to improve soil moisture retention.

58. Zara Rutherford, aged **19**, embarked on a solo flight around the world to inspire girls to pursue aviation and STEM fields.

59. Ishita Katyal, aged **10**, delivered a TED Talk on the power of childlike curiosity and the importance of nurturing young minds.

60. Jack Andraka, aged **16**, invented a paper sensor that can detect pancreatic, ovarian, and lung cancer with high accuracy and low cost.

61. Barrington Irving, aged **23**, became the youngest person and the first African American to fly solo around the world.

62. Richard Turere, aged **13**, developed a system using solar-powered lights to protect livestock from lion attacks in Kenya.

63. Yassmin Abdel-Magied, aged **19**, built a race car and competed in the Formula SAE competition, becoming the first Muslim woman to do so.

64. Amelia Day, aged **17**, developed a mobile app called "Treetop Travel" to help people with disabilities navigate public spaces.

65. Gitanjali Rao, aged **12**, invented a device called "Epione" that uses artificial intelligence to detect early-stage prescription opioid addiction.

66. Maria Elena Grimmett, aged **16**, developed a mobile app called "Safe & Sound" to provide

resources and support for teenagers facing mental health challenges.

67. Anne-Marie Imafidon, aged **11**, passed her advanced-level A-level computing exam and became the youngest person to do so in the United Kingdom.

68. Rishab Jain, aged **14**, developed an artificial intelligence system that helps doctors locate and treat pancreatic cancer more effectively.

69. Rebecca Garcia, aged **23**, is a computer scientist and advocate for diversity in technology who co-founded CoderDojo NYC to teach kids how to code.

70. Fionn Ferreira, aged **18**, developed a method to remove microplastics from water using a magnetic liquid and won the Google Science Fair.

71. Kimberly Anyadike, aged **15**, became the youngest African American female pilot to fly solo across the United States.

72. Kenneth Shinozuka, aged **15**, invented a wearable sensor that alerts caregivers when Alzheimer's patients wander off.

73. Elif Bilgin, aged **16**, developed a biodegradable plastic made from discarded banana peels, addressing environmental waste.

74. Tanmay Bakshi, aged **14**, is a software developer and AI expert who started coding at the age of five and has published books on coding and AI.

75. Roya Mahboob, aged **23**, founded the Afghan Citadel Software Company to empower women in Afghanistan through technology and education.

76. Shree Bose, aged **18**, discovered a potential treatment for drug-resistant ovarian cancer and won the Grand Prize at the Google Science Fair.

77. Richard Turere, aged **12**, invented a solar-powered device to protect crops from elephants in Kenya, reducing human-wildlife conflicts.

78. Angela Zhang, aged **17**, developed a nanoparticle-based cancer treatment that selectively targets tumor cells while minimizing damage to healthy cells.

Young S.T.E.A.M Achievers

79. Jackson Oswalt, aged **12**, became the youngest person to achieve nuclear fusion in a controlled environment in his own backyard.

80. Jack Andraka, aged **18**, developed a paper sensor that detects pancreatic, ovarian, and lung cancer with 90% accuracy and costs only 3 cents.

81. Mallory Kievman, aged **13**, invented a lollipop called "The Hiccupop" that helps soothe hiccups.

82. Anne-Marie Imafidon, aged **11**, passed her advanced-level A-level computing exam and became the youngest person to do so in the United Kingdom.

83. Sushma Verma, aged **15,** became the youngest student to complete a master's degree in microbiology.

84. Sabrina Gonzalez, aged **17,** developed a renewable energy system using algae and won the Intel Science Talent Search.

85. Kelvin Doe, aged **16,** built his own FM radio station using discarded electronic parts and became a local DJ in Sierra Leone.

86. Amy O'Toole, aged **10**, became the youngest published scientific researcher by contributing to a project on the spread of disease.

87. Matthew Mullenweg, aged **19**, co-founded WordPress, one of the most popular website creation platforms globally.

Young S.T.E.A.M Achievers

88. Krtin Nithiyanandam, aged **16**, developed a potential treatment for Alzheimer's disease by targeting amyloid plaques.

89. Advait Thakur, aged **15**, created a smart glove that translates sign language into spoken language to aid communication.

90. Pooja Chandrashekar, aged **17**, developed an algorithm to improve early detection of Parkinson's disease.

91. Ananya Vinay, aged **12**, won the Scripps National Spelling Bee, showcasing her linguistic talent.

92. Raghav Sood, aged **15**, developed an app called "Grades" to help students track their academic progress and manage their assignments.

Young S.T.E.A.M Achievers

93. Yuma Soerianto, aged **13**, created numerous apps and games, becoming one of the youngest app developers in the world.

94. Avi Schiffmann, aged **17**, developed a website called "ncov2019.live" to track COVID-19 cases globally in real-time.

95. Angela Zhang, aged **17**, won the Siemens Competition in Math, Science & Technology for her research on cancer treatment.

96. Richard Turere, aged **13**, invented a solar-powered system to deter lions from attacking livestock in his village.

97. Alex Deans, aged **15**, created a company called "iAid" and developed a wearable device to assist visually impaired individuals.

98. Britney Exline, aged **19**, became the youngest African American woman to attend an Ivy League medical school.

99. Ben Pasternak, aged **19**, developed several successful mobile apps and was named one of Forbes' "30 Under 30" in Technology.

100. Jonah Kohn, aged **14**, developed a mobile app called "Cram" to help students create and share digital flashcards.

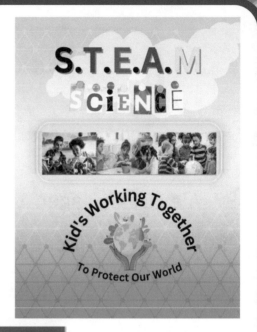

**Other books
by Portia George
Amazon.com**

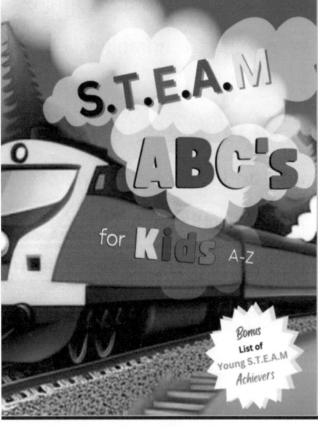

School

Know Our History

Our
Black History
"Unapologetic Expression:
Poems of Strength and Identity
for
Young Black
Kings and Queens"

Poems

Black Pride
Year-Round
A Monthly Celebration Book
365
January-December

Soulful Celebrations:
National Black Holidays

Complete
To Mark Your
200+ Dates
Celebration Dates
With Calendar

"Return and get it"
365 Lest We Forget Too!

Complete Glossary
Bonus
250 Fun Facts

"Rhythmic Roots:
African American
Nursery Rhyme
Treasury"

For

"Our Precious Posterity"

Other books
by Portia George
Amazon.com

S.T.E.A.M
Science Bible
@
Working Hand & Hand
To Protect Our World

†Christian
S.T.E.A.M
ABC's
for Kids A-Z

Bonus
Stories - Bible Verses
Life Applications
Young Achievers list

Church

Other Titles

Coloring /Puzzles

Coloring /Puzzles

Names of God
and their meanings

Elohim
The strong, creator God

150 Adult Coloring Pages

Valentine's
50 WORD SEARCH
Puzzles

Sweets

LOVE YOU

Lest We Forget
Know Your History
50 WORD SEARCH
Celebration Puzzles

Fun Facts
Bonus
250 Fun Facts

PUZZLE #15

Give them the Tools they Need Today!

Complete with Glossary

Amazon.com

Put It on Their Ipads

Cursive Writing

Journals

Specialty
High Heel Collections
Journaling Catalog

Cowgirl
Boots & Hats
Journaling Catalog

SNEAKER
Journaling Catalog

Cowboy
BOOTS & HATS
Journaling Catalog

Other Titles

Made in the USA
Columbia, SC
20 February 2024

31769578R00063